PETER AND ALICE
a new play by
JOHN LOGAN

methuen | drama
LONDON • NEW YORK • OXFORD • NEW DELHI • SYDNEY

METHUEN DRAMA
Bloomsbury Publishing Plc
50 Bedford Square, London, WC1B 3DP, UK
1385 Broadway, New York, NY 10018, USA
29 Earlsfort Terrace, Dublin 2, Ireland

BLOOMSBURY, METHUEN DRAMA and the Methuen Drama logo
are trademarks of Bloomsbury Publishing Plc

First published in Great Britain by Oberon Books 2013
This edition published by Methuen Drama 2021

Cover photography: Hugo Glendinning and Bronwen Sharp
Cover design: Dewynters

Bloomsbury Publishing Plc does not have any control over, or
responsibility for, any third-party websites referred to or in this book. All
internet addresses given in this book were correct at the time of going
to press. The author and publisher regret any inconvenience caused if
addresses have changed or sites have ceased to exist, but can accept no
responsibility for any such changes.

All rights whatsoever in this play are strictly reserved and application
for performance etc. should be made before rehearsal to Creative Artists
Agency of 405 Lexington Avenue, 19th Floor, New York, NY 10174 USA.
No performance may be given unless a licence has been obtained, and
no alterations may be made in the title or the text of the play without the
author's prior written consent.

A catalogue record for this book is available from the British Library.

ISBN: PB: 978-1-3502-6591-2
eBook: 978-1-8494-3841-4

To find out more about our authors and books visit www.bloomsbury.com
and sign up for our newsletters.

NOTE:

Many years ago I came across the following in *The Real Alice*, Anne Clark's biography of Alice Liddell Hargreaves, the model for Lewis Carroll's Alice in Wonderland:

"*On June 26 1932 Alice opened the Lewis Carroll exhibition at Bumpus, the London bookshop. Beside her was Peter Davies, the original Peter Pan.*"

I wondered what they said to each other.

Peter and Alice by John Logan was first performed in London on 9th March 2013 at the Noël Coward Theatre as part of the Michael Grandage Company Season of five plays.

Cast (in order of speaking)

PETER LLEWELYN DAVIES	**Ben Whishaw**
ALICE LIDDELL HARGREAVES	**Dame Judi Dench**
LEWIS CARROLL (REV. CHARLES DODGSON)	**Nicholas Farrell**
JAMES BARRIE	**Derek Riddell**
PETER PAN	**Olly Alexander**
ALICE IN WONDERLAND	**Ruby Bentall**
ARTHUR DAVIES/REGINALD (REGGIE) HARGREAVES/ MICHAEL DAVIES	**Stefano Braschi**

Understudies

ALICE IN WONDERLAND	**Georgina Beedle**
LEWIS CARROLL/JIM BARRIE	**Henry Everett**
PETER LLEWLYN DAVIES/ PETER PAN/ARTHUR DAVIES/ REGGIE HARGREAVES/ MICHAEL DAVIES	**Christopher Leveaux**
ALICE LIDDELL HARGREAVES	**Pamela Merrick**

Creative Team

Director	**Michael Grandage**
Set and Costume Designer	**Christopher Oram**
Lighting Designer	**Paule Constable**
Composer and Sound Designer	**Adam Cork**

Dedicated to Michael Grandage

For his faith in this play and its author.

And for giving an actor the single best piece
of direction I have ever heard.

The backroom of the Bumpus bookshop in London. June 26, 1932.

Imposing shelves of books, files, bibliographic supplies, etc. There is a door into the bookshop.

PETER waits. He's in his 30s.

He hears voices off. He prepares himself, clears his throat, and straightens his conservative suit. He's nervous.

ALICE enters.

She's 80.

PETER: Mrs. Hargreaves… My name is Peter Davies. How do you do?

ALICE: How do you do?

PETER: We're to wait here. I'm told.

Beat.

PETER: It'll only be a few minutes, until everyone has gathered and then Charles will introduce me and I'll introduce you. You're to make some remarks and then–

ALICE: I understand.

Beat.

PETER: This is a – pleasure, ma'am.

ALICE: You were going to say "honor" but you thought it unduly reverential. It is challenging to know which note to strike with me. Do you honor him and the book through honoring me? But am I worthy of honor? Not her – me… Then how, indeed, do I feel about her? You've no way of knowing… Is it an "honor" or a "pleasure"…or something else altogether?

PETER: I think, now, the latter.

She smiles slightly.

He's emboldened to continue.

PETER: In any event, Mrs. Hargreaves, I've been looking forward to meeting you.

ALICE: No, Mr. Davies, I daresay you've been looking forward to meeting <u>her</u>.

PETER: It is to <u>you</u> I wish to speak.

ALICE: Is this by way of an ambush?

PETER: I asked Charles if I might have a few words with you.

She nods. Proceed.

PETER: I have an imprint, not inconsiderable, called Peter Davies Limited. We have a proper list and my chief duty as publisher is to cast my eye about for worthwhile subjects.

ALICE: And your eye has fallen on me, as worthwhile. How very flattering.

PETER: That's the curse of my trade. To a book man, every nook and cranny is a potential story.

ALICE: Am I a nook or a cranny?

PETER: I – Sorry?

ALICE: Come to the point, Mr. Davies.

PETER: When I got the invitation to come and meet you, I thought: there's a story, and worth the telling… Have you considered your memoirs?

ALICE: Considered them as what?

PETER: Something you might wish to write.

ALICE: To be published and vended?

PETER: Yes.

ALICE: This is not the first time I've been approached.

PETER: Perhaps never by someone with such a <u>personal</u> understanding of your unique position.

ALICE: Have I a "position"?

PETER: Come now, Mrs. Hargreaves, you would not be here today if you did not.

She grants the point.

ALICE: Memoirs – autobiographies – are the records of the deeds of a life. I have had no deeds worthy of reportage. Not of my own... Those around me perhaps.

PETER: Isn't every life worth recording honestly?

ALICE: Oh... You want honesty.

Beat.

ALICE: Aren't you the ambitious young man?

She strolls, considers the room.

ALICE: In your element, Mr. Davies.

PETER: Sorry?

ALICE: Amongst the books.

PETER: For you as well.

ALICE: I was not amongst the books, I was in a book. That's something different.

She runs her hand along some of the spines.

ALICE: From the outside they are one thing: ordered and symmetrical, all the same; like foot soldiers. From the inside they are altogether singular.

PETER: Do you ever get tired of it?

ALICE: What?

PETER: Being Alice.

ALICE: I'm loath to disillusion you, but people have forgotten me. Thus I fear for the commercial prospects of the House of Davies should you be so reckless as to publish my memoirs. Of course they remember her. But me? ... Those days are like the dark ages now, aren't they? Before motor cars and chewing gum. Before airplanes and cinema and

the wireless. Lord, a time before the <u>wireless</u>, can you imagine the silence? You could hear the bees buzzing in the summer... Golden afternoons all gone away.

PETER: With respect, Mrs. Hargreaves, people have not forgotten. Everything associated with the Centenary is taking the fancy of the nation, including the reception today.

ALICE: Momentarily, yes... But before this there was, and after this there shall be, quietude. I like to hear the bees buzzing.

PETER: But don't you think – ?

ALICE: *(Firm.)* No, sir, I do not. In your quest for literary "truth" you must occasionally run across those stories you wish you hadn't told, for the simple reason that no one really wants to hear the truth when it runs contrary – "contrariwise" as he would say – to the comfortable assumptions that people hold so dear. That's the burden of truth, isn't it?

PETER: Yes, but–

ALICE: Here's a burden: the only reason anyone remembers me now as Alice in Wonderland is that I decided to sell my hand-written manuscript of the book. It was this act that brought me back into the public eye... But do you know <u>why</u> I sold the manuscript? Because I needed the money. <u>To heat my house, Mr. Davies</u>... Now, is that the Alice people want to know? Or is it just possible they would rather remember that little blond girl in the dress, eternally inquisitive, impossibly bold, never changing and never growing old?

PETER: <u>But we all grow old!</u> ... That's the story of our lives: the one immutable; the one inescapable. The crocodile in the lagoon, the iceberg on the horizon, death just around the corner, tick tick tick. I'm grasping now but–

ALICE: *(Interrupts.)* <u>What's your name</u>?

PETER: Peter Davies, ma'am.

ALICE: All of it.

PETER: Peter Llewelyn Davies.

ALICE: Peter Pan.

Beat.

PETER: There were five of us.

ALICE: Well, this is rich!

PETER: I suppose so.

ALICE: And a little bizarre.

PETER: Mm.

ALICE: Were you planning on telling me?

PETER: No, actually, I wasn't intending –

ALICE: Of course not. But how could you help being who you are?

PETER: And how can you?

It's a bit of a challenge.

She moves around the room.

ALICE: Alice in Wonderland and Peter Pan. We're practically our own children's book department… There were five of you?

PETER: Five boys, yes. Five brothers… And there were three sisters?

ALICE: Yes, we three Liddell girls, back in Oxford.

PETER: But you're "Alice."

ALICE: As you're "Peter"… But after all, what's in a name?

PETER: What isn't?

She understands.

ALICE: With me, it has been a wholly happy connection. When people find out, they always smile, for they're

bringing so many associations with them: first time hearing the story; first time reading the book; then reading it to their own children. You see it in their faces, the pictures behind that smile of recognition: the White Rabbit; the Mad Hatter; the Cheshire Cat. I think they smile because what they're really remembering is <u>themselves as children</u>, and for that moment I see the wonder returning to them… When I look over my days I feel I was given a gift by Mr. Dodgson. Out of everyone, there's only one Alice. He made me <u>special</u>. And that uniqueness has given me a lifetime of people looking back at me, with a growing smile, remembering their better selves, when they were new and life was before them and all they needed to find their way through was a little courage, a little imagination, and a bottle labeled "Drink Me."

PETER: I heard that speech on the wireless a few weeks ago.

ALICE: Well it is my speech.

PETER: Very effective.

ALICE: I'm glad you think so. You'll be hearing it again in a few minutes.

PETER: Lovely words. But we know better though.

ALICE: Do we?

PETER: I think so.

ALICE: You're presumptuous.

PETER: The truth isn't so easy.

ALICE: Ah, there's the "truth" again.

PETER: Let me tell you the rest of the story and you tell me… So, yes, the smile of recognition, all the associations coming back: the first time they saw the play; the first time they read the book. Peter and Wendy. Neverland. Captain Hook. Tinkerbell… But a second after those happy memories comes that look of confusion and doubt, and then this in their eyes: "But how can you be Peter Pan?

You? The Boy Who Never Grew Up? That's not you. You have egg on your collar. You can't fly. You're not Alice. Alice was a little blond girl, I know she was. You're lying to me." <u>And then they remember</u>. <u>What growing up really is</u>: when they learned that boys can't fly and mermaids don't exist and White Rabbits don't talk and all boys grow old, even Peter Pan, as you've grown old. They've been <u>deceived</u>. As if you've somehow been lying to them. So following hard on the smile of remembrance is the pain in the eyes, which you've caused, every time you meet someone.

ALICE: How can you say it's a lie? They're just stories.

PETER: As a publisher I've an obligation to tell the truth.

ALICE: You talk like a very young man, and callow. The truth isn't a mathematical equation that always works out to the precise sum. It's variable. It's mutable. Lord, the longer I live the more I know there's no such thing as <u>certainty</u>! There are only passing moments, and I savor the ones that bring me some damn comfort in a cold house. If it's a lie, why does it keep me warm?

PETER: It doesn't and it can't.

ALICE: You're presumptuous again.

PETER: I'm sorry.

ALICE: You're not at all. You think you're being clever: "No one gets the better of me. I see the world as it really is. I'm a marvelous honest fellow. Pity the poor old lady living in her memories of things that never happened." You're so young. You are the Boy Who Never Grew Up!

PETER: Believe me; the one thing I thoroughly know is <u>growing up</u>!

ALICE: Then tell me.

PETER: What?

ALICE: What is "growing up" precisely?

PETER: Well, I suppose…

ALICE: Specifically.

PETER: I don't know that I can —

ALICE: It's the one thing you "thoroughly know."

PETER: Well, it's <u>complicated</u> —

ALICE: Is it?

PETER: I wouldn't know where to start —

ALICE: Was it the day you realized your parents aren't perfect? When you got your first long trousers? Going to school? Saying hello? Saying goodbye? Your heart opens? It breaks? It heals? It breaks again? Which is it?

PETER: When you realize what life is.

ALICE: Too vague. You're after the <u>truth</u>, aren't you? Being a publisher and all?

He looks at her. She is like iron staring back at him.

He reorients himself in the room.

PETER: Do you think back on your life?

ALICE: As rarely as possible.

PETER: Will you try?

ALICE: Why should I?

PETER: To help me understand. We can swap a truth for a truth.

ALICE: I'm not sure I trust you…

PETER: Who but me? Peter and Alice.

Suddenly, a man's voice is heard:

CARROLL: *(Offstage.)* <u>Alice</u>! … <u>Alice</u>! Where have you gone?

ALICE is utterly shocked at this voice from her past.

CARROLL: *(Offstage.)* Are you hiding, Queen Alice?

PETER: Yes, of course that's how it begins: a harmless fairy tale to pass the hours…

The bookstore disappears around ALICE and PETER.

We're in their minds and memories now.

LEWIS CARROLL sidles up to ALICE. He's slanted, awkward, partly deaf and painfully shy.

CARROLL: I can't do it without you, my lady. What am I without you? But then, <u>what are you without me</u>? … Take my hand.

He offers his hand.

CARROLL: Be young again.

PETER: Who wouldn't want that?

CARROLL: Be young forever.

PETER: He offers your heart's desire.

ALICE: Stop the clocks. Turn down the lights. In the glass, the wrinkles fade away. The skin is fresh again. The bones don't ache. To be always poised on the verge of the great adventure. Everything <u>just ahead</u>.

CARROLL: Take my hand, little Alice.

PETER: But there's a price. He feeds on your youth.

ALICE: Or do I feed on his experience?

This stops PETER.

She looks deeply at CARROLL.

ALICE: Are we to have a story on the river?

CARROLL: We shall have whatever you like.

ALICE: Please then, Reverend Dodgson, <u>a story</u>.

She takes his hand.

PETER: And it's done… That first touch.

ALICE: His skin is soft! Like a pampered man who never uses his hands. It's repulsive… But it didn't feel so then.

PETER: Your hand was less used to other hands then.

CARROLL strolls with her.

It's a hot summer day, the lovely buzz of insects. It is 1862.

CARROLL: Well, first things being first: if we're to have a story then we must have a p-p-p–

The word doesn't come. His mouth gapes horribly.

This is his stammer.

He starts to panic.

CARROLL: P-p-p-p…

ALICE: Pirate? Poetess?

PETER: Protagonist?

CARROLL: P-p-protagonist. Who shall be our heroine? Shall it be one of your sisters? Shall it be Lorina? Or shall it be Edith?

ALICE: Me!

CARROLL: Why you then, Alice?

ALICE: Because I am your dream child. Because they're awfully silly and I'm not. We understand each other, Mr. Dodgson.

CARROLL: Like two cryptographers, unlocking the same secret.

ALICE: I don't know that word.

CARROLL: That's a word you learn when you're eleven, along with crepuscular and cantilevered… So if we can't be cryptographers, perhaps we'd best be polar explorers, roped together lest a crevasse or snow-blindness make us lose our way.

ALICE: I don't see how one can become blind in snow. I could see losing your way in a cave, or at the bottom of the sea.

PETER: Or in memory.

CARROLL: I wonder if we'll lose our way someday, Alice?

ALICE: I would think that depends on where we're going in the first place.

PETER: You weren't that clever.

ALICE: I am now.

CARROLL: It's a simple thing to get lost, you know. You glance around and suddenly everything's changed. Nothing's like it was, even you in the looking glass. Who you thought you were, you're not... And you don't need to be exploring another c-c-c-continent either. You can lose your way right here in Oxford if you're not careful. Right over that hedge.

ALICE: Or down that rabbit hole.

PETER: You didn't bait him like that.

CARROLL tells a story. He's enchanting.

The buzzing of the insects becomes intoxicating music.

CARROLL: So imagine a day like this and a girl like you and a sister like Lorina and you find yourself on a riverbank, and there's a rabbit hole nearby, and perhaps you had one too many jam tarts this morning, so you're ever so soporific, which is a twelve-year-old word in truth, so on this particular, peculiar day you fall asleep...

CARROLL continues quietly.

ALICE: The maladroit stutter, the slanting body, the dreadful shyness all disappeared that afternoon, that golden afternoon when I was ten and we went up the river with my sisters, and we were in the shadow of a haycock because it was blazing hot, and he told the story of Alice underground, <u>my</u> story, which would have died like one of the summer midges, like all the others, only this time I

asked him to write it down, because I was the heroine, that day he was <u>beautiful</u>.

Beat.

ALICE: That day he had all he needed... He had his story.

PETER: But what man can live on words?

ALICE: He was a writer.

PETER: He was a man.

ALICE: Not much of one.

He looks at her, the sharpness surprising.

She moves away from CARROLL. CARROLL remains. (Once characters are introduced they remain on stage. Lingering like memories or ghosts.)

ALICE: Not the way I've come to know men, adult men. He was a perpetual child.

PETER: There's no such thing.

ALICE: You didn't know him.

She moves away from him. He pursues.

PETER: Did you?

ALICE: For several years he was at the very center of our lives.

PETER: "The center of your lives?"

ALICE: Yes. He'd tell us his stories, on the green or rowing on the river, and then off he'd go to let us dream about them.

PETER: And where did he go?

ALICE: I beg your pardon?

PETER: When he left you, where did he go, what did he do?

ALICE: I don't know... I imagine he returned home and went on with his life.

PETER: No. He didn't. <u>You</u> were his life.

She stops.

PETER: It's just like Barrie with us… You weren't a "dream child." You were a child of flesh and bone. He looked into your eyes and you looked back.

ALICE: We were a diversion, no more. He was a grown man with an important career and friends of his own… Three adolescent girls, all giggles and elbows? I'm sure he was happy to go home and forget us.

PETER: Grown men do not "return home and go on with their lives." That's what children do. Children pass gaily through life with no sense of the weight of events… Grown ups look in the mirror, and then look at the clock… They walk into an empty house that feels emptier every day that passes, for it brings them ever-closer to the final and inescapable loneliness: that last echoing room where you are truly alone.

Beat.

PETER: There are no simple childhood memories, Mrs. Hargreaves. I told you, it's complicated. Everything's occluded.

ALICE: How do you know he was lonely?

PETER: Ah… If he were not, would he have loved you so much?

ALICE: How do you know he loved me?

PETER: Would he have written the book otherwise?

ALICE: So…it's to be a love story.

PETER: Aren't they all?

A voice surprises him:

BARRIE: *(Offstage.)* No, Peter, you're wrong… There's no love in it! No romance, I promise you that…

JAMES BARRIE enters briskly and goes toward PETER. He's a stunted, sad, inspiring Scotsman.

BARRIE: There's not a jot of love or moonlight to be had,
except for that moon which can be glimpsed at dead
midnight over the Tyburn gallows after those bloodthirsty
brigands have met their end and sway from the gibbet.
Gather 'round, lads…

He continues his story. It is 1901.

Music builds.

BARRIE: Here at Black Lake Cottage there's a lake which
– you will not be surprised to learn – is black. But do
you know <u>why</u> it's black? Not the murky water, though
tolerably murky it is. Not the depth of it where no light can
pass, though deep it is. It's black because of the souls of all
the dead men trapped at the bottom, it's been blackened
by wickedness, by them that walked the plank, that felt the
touch o' the cat, that had their throats slit by that fearsome
captain afore his breakfast. What's his name again?

PETER: I can't remember…

ALICE: You mean you can't forget.

BARRIE: What's his name again, Peter?

PETER: Really, I don't –

ALICE: You do.

BARRIE: Come on now! … Feel the spray of the ocean, like
you used to when you were a boy; when you wanted to sail
the seas on a triple-master, like every boy does, to see the
world, to have adventures, to fly and fight and fly again.

CARROLL: Be young forever.

BARRIE: What's his name, that piratical gentleman who had us
quaking under the covers at night?!

PETER: <u>Hook</u>!

BARRIE: Yes, Hook! Now you're with me! You're on the deck
of the mighty galleon as it rolls and pitches, and we're
lashed to the wheel together, lad, through the cataracts!

PETER: 'Round the Horn!

BARRIE: Until the maelstrom passes!

ALICE: Do you feel your heart pounding?!

PETER: Yes! Like racing passion, like love!

ALICE: So in a flash you're young again!

PETER tears himself away. The music fades.

ALICE: Can't help yourself.

PETER: You get caught up.

ALICE: I know.

PETER: You can't breathe.

ALICE: You don't want to.

PETER: That's their power, these writers, these men of words. Trap baited and sprung, and before you know it you have to chew your leg off to get free.

ALICE considers BARRIE.

ALICE: In truth he was a little man.

PETER: Not when he told his stories.

ALICE: Who's the romantic now? … I met him at a reception once and was surprised to find him so terribly diminutive. Famous people should not be so tiny, it seems dishonest.

PETER: From the first day, he was all words. My brothers and I were playing in the park and the most enormous dog came bounding over. His dog, Porthos, like a lure it was.

ALICE: There's that trap again.

PETER: How he enmeshed himself in our lives! Before long he was following us home and staying for supper, seemed to think it was his right. He just…<u>acquired us</u>… My father was so uncomfortable with him, fully aware he was being supplanted, but what was he to do? My mother loved him, as did we boys… Snap. The trap was sprung.

He looks at BARRIE.

PETER: You plain mesmerized us.

BARRIE: I made you famous.

PETER: I didn't ask for it.

ALICE: Didn't you?

PETER: For god's sake, I was a child. I didn't know anything!

ALICE: You listened. You laughed. You sparkled for him. You wanted him to look at you most, to look at you longest. To love you best.

CARROLL: You're my favorite, Alice. You'll always be my favorite.

ALICE: Your brothers were <u>rivals</u>.

PETER: Were your sisters?

ALICE: Yes.

PETER: It wasn't that way with us. We were a band of brothers.

BARRIE: My Lost Boys.

ALICE: I can see the five of you, each craning over the other, crawling over his lap like puppies. Whose eye will he catch? Who'll make him smile today?

PETER: <u>Michael</u>.

ALICE: What?

PETER: He loved Michael most... Uncle Jim always said that he made Peter Pan by rubbing the five of us violently together, as savages with two sticks produce a flame. But that's not true. It was Michael, bold and fearless Michael... I was never bold. I always had fear.

ALICE: Of what?

PETER: What does every child fear? ... Captain Hook.

ALICE: The character?

PETER: The idea. Means something different for every boy I expect... For me it was no more summers of pirate yarns and playing in the grass. All the boys going to school, moving away and getting separated. My brothers not being my brothers anymore, being someone else's husband or father, but not my brothers, not really, not like it was. No more father and mother... Just me... That's a piece of growing up, isn't it? Learning to name the thing you fear? ... Captain Hook.

CARROLL: Or the Red Queen.

ALICE: Children's stories can't hurt you.

PETER: You know better.

ALICE: They don't exist. There is no Captain Hook.

PETER: Are you sure? Don't you sometimes feel him? ... When you're alone, in a dark room, the point of his hook touching the back of your neck?

ALICE: They can't hurt you. Not once you grow up.

CARROLL goes to her:

CARROLL: But, Alice, you must never grow up! <u>Promise me!</u>

ALICE: Really, how can I help from growing up?

CARROLL: Ah, the question of the ages. We'll have to ask a wise old tortoise. Shall we stroll?

She's disturbed by this bit of her past.

ALICE: That long summer. God, would it never end? ... We were walking in town. There were illuminations that evening and the street was radiant. My sisters and our governess had wandered ahead, so it was just Reverend Dodgson and me... It was so rarely that, just the two of us alone. Only twice that I can recall.

PETER: Truly?

ALICE: It was a different era, Mr. Davies. Unaccompanied in the presence of a gentleman? It wasn't done... I can only remember two times. This was the first...

Gentle and magical illuminations light the stage.

CARROLL and ALICE stroll. It is 1862.

ALICE: But why mustn't I grow up? It seems the most marvelous thing in the world to be old and wear gowns and gloves and hats with feathers.

CARROLL: Oh, hats with feathers are admirable things, but along with them goes something altogether unlike gowns and gloves. First the squint in the eye and then the hard set of the mouth, followed in quick order by the wagging tongue and the shaking finger. One day you turn around and you've become Mrs. Grundy: soberly disapproving of everything that used to give you pleasure.

ALICE: I can't imagine that! Shan't I always be able to laugh at things?

CARROLL: Does your mother laugh much?

ALICE thinks about this.

ALICE: No... Not so much as she used to perhaps.

CARROLL: And it seems to me even our Lorina is not so amused as she used to be.

ALICE: She got her first corset, you know.

CARROLL: Alice, you shouldn't talk about such things to a gentleman.

ALICE: It's made out of whale bone!

CARROLL: That's why the leviathans are so terribly fat. They've given all their corsets to little girls in Oxford.

ALICE speaks to PETER:

ALICE: I watched my sister putting on her corset for the first time. I shall never forget it... My mother sat us down, all three girls, and produced it from a gorgeous purple box,

made of Venetian paper I think. I was intoxicated by the box. And then the bone of the corset was <u>iridescent</u>. Here was growing up and becoming a woman: and it was <u>beautiful</u>… My mother helped Lorina put it on and tighten the laces. Well then I could see it hurt. Lorina cried… And my mother, the look on her face. She was not a woman given to displaying vulnerability. She was our soldier. But on her face… What was it? Not quite sadness. Acceptance. Resignation to something vast, and helpless to change it. Powerlessness… Here was growing up too.

CARROLL: We'll have to watch Lorina carefully, like a fever-sufferer, and at the first sign of the censorious eye, we'll strike.

ALICE: What'll we do?

CARROLL: Make her stand on her head.

ALICE is amused.

They walk for a moment.

CARROLL is thinking about something.

CARROLL: It's only a matter of the clock now. She'll be up and married and raising a litter of her own soon.

ALICE: Lorina?! She's still a baby.

CARROLL: She's 13. That's a whole year past the age of consent.

They walk for a beat.

CARROLL: Why, in two years <u>you</u> could get married.

There is weight to this.

ALICE: What was he trying to say?

PETER: You know exactly.

ALICE: <u>I was ten years old.</u>

PETER: You had fascinated him. Beaten out your sisters, like you said; your rivals. You sparkled for him. You got your wish.

ALICE: Stop it.

PETER: Don't you like love stories?

CARROLL: Alice, will you not look at me?

PETER: I thought all little girls enjoyed love stories.

ALICE: You're a terrible man.

PETER: And what kind of child were you?

ALICE: A child is what I was!

PETER: Not after that night. Might as well start chewing off your leg.

ALICE: You don't know anything about it! You didn't walk with him. You didn't feel his suffering. Like a vibration next to me, like a tuning fork, his need was overwhelming.

CARROLL: Alice? Please look at me.

ALICE pretends to peer ahead for her sisters.

ALICE: Where have they gone? Can you see my sisters? I should catch up with them.

CARROLL: Of course.

ALICE: All right. See you later, sir.

CARROLL: Alice – I've almost finished your story.

ALICE: You're writing it down, I'd forgotten. That's marvelous.

She moves off quickly.

CARROLL immediately stops walking. He stands alone.

ALICE recovers herself.

ALICE: What would I have done if I looked back and saw him standing there? Would my heart have broken?

PETER: Does it now?

ALICE: Children don't have hearts yet, not really. They haven't been hurt into the need for one… You know, Mr. Davies, I think they were born out of sadness, Alice and Peter. Out of <u>loneliness</u>, wouldn't you say?

PETER: Uncle Jim was the loneliest man I ever knew. For a time he could be a part of us, one of the boys, but that couldn't last because…

He stops, realizing where this has gone, inevitably…

PETER: *Because all children, except one, grow up…*

PETER PAN flies in. He's full of bravado and nerve and looks exactly as you imagine PETER PAN to look.

PETER PAN: *I ran away the day I was born! I heard father and mother talking about what I was to be when I became a man. I don't ever want to be a man. I always want to be a little boy and to have fun. So I ran away to Kensington Gardens and lived a long long time among the fairies.*

PETER: He created the one boy who would never grow up and leave him.

ALICE approaches PETER PAN:

ALICE: *Wendy felt at once that she was in the presence of a tragedy.*

PETER PAN: *Would you like an adventure now, or would you like to have your tea first?*

ALICE: *What kind of adventure?*

PETER PAN: *I'll teach you how to jump on the wind's back, and away we go!*

PETER: Away we go…

BARRIE: To fly and fight and fly again. Shall we do that, Peter?

PETER PAN: *How clever I am! Oh, the cleverness of me!*

CARROLL, who has not moved, looks up.

CARROLL: *Alice was beginning to get very tired of sitting by her sister on the bank, and of having nothing to do: once or twice she had*

peeped into the book her sister was reading, but it had no pictures or conversations in it…

ALICE IN WONDERLAND pops up from a trap door, like one of the Tenniel illustrations come to life. She's a bold and curious girl.

ALICE IN WONDERLAND: *And what's the use of a book without pictures or conversations?!*

CARROLL: *So she was considering, in her own mind…*

ALICE IN WONDERLAND: *As well as she could, for the hot day made her feel very sleepy and stupid…*

CARROLL: *Whether the pleasure of making a daisy-chain would be worth the trouble of getting up and picking the daisies –*

ALICE IN WONDERLAND: *When suddenly a White Rabbit with pink eyes ran close by her!*

PETER PAN and ALICE IN WONDERLAND linger nearby.

They are curious about their real-life counterparts. They interact, examine, imitate, and shadow them periodically throughout the play.

ALICE: Once she was born, part of me ceased to exist. As if she had taken part of me.

PETER: Or like a brother.

ALICE: Yes! Like I had another sister.

PETER: Another rival?

ALICE: No, a twin… A shadow.

PETER: That's it.

ALICE: Even when I had forgotten her for weeks on end, years on end, I would turn, and even be a little surprised, for there she was.

PETER PAN shadows PETER, almost like a game for him. Not for PETER though.

PETER: Sometimes I tried to forget him. Always I tried to forget him. It was unremitting my whole life: "Peter Pan joins the Army", "Peter Pan marries", "Peter Pan opens

publishing firm" … There was a time I drank terribly to forget him. I still do, there's the truth. Or threw myself into love affairs, high drama, anything to forget the shadow. But, invariably, on the happiest of days, when he had been banished fully, I would catch a glimpse…in the shaving mirror…the shop window…behind me on the pavement.

ALICE: Why did you try to banish him?

He doesn't answer.

ALICE IN WONDERLAND: *Wendy had looked forward to thrilling talks with Peter about old times, but new adventures had crowded the old ones from his mind.*

PETER PAN: *Who's Captain Hook?*

ALICE IN WONDERLAND: *Don't you remember how you killed him and saved all our lives?!*

PETER PAN: *I forget them after I kill them.*

PETER: Because he makes me <u>remember</u>.

Beat.

This doesn't come easily.

PETER: When I look at my own children, Mrs. Hargreaves, I think…I think I know what childhood's for. It's to give us a bank of happy memories against future suffering. So when sadness comes, at least you can remember what it was to be happy.

ARTHUR LLEWELYN DAVIES, PETER's father, enters.

His neck and jaw are in a horrible leather brace. He is dying. It is 1907.

PETER: When it came, I was nine years old. Up until that time we were boys. After that time we were not.

ARTHUR sits painfully.

PETER PAN approaches, watches, almost impassive.

PETER: My father... It was a cancer of the jaw and mouth. The word was never spoken in our house. It was a filthy word... Well, the operations began for this thing we didn't say, and didn't end until they had removed half his upper jaw and his palate and his cheekbone. For a time he had an artificial jaw, which was monstrous, he was so disfigured. I couldn't look at him he frightened me so much, my father, more than Captain Hook, more than anything... He could barely speak. And every word had to be carefully chosen for the effort it cost him.

BARRIE sits with ARTHUR. He's very gentle with him.

PETER: Barrie was magnificent those last days. The best he ever was. So kind to him, to us all... He paid for everything, you see. My father had lost his job. No one wants a barrister who can't speak, who looks like that... There was no money and no prospects so in the end, my father was trapped...

BARRIE: Don't speak, Arthur. Let me tell you about the boys. George wrote to me from Eton that he wants to come for the weekend, but I wonder if –

ARTHUR: Jim.

BARRIE: Are you sure you should?

ARTHUR holds up a hand, he must try to speak.

This is agony:

ARTHUR: There is no money... There is my wife... There are five boys.

It is too hard to continue.

BARRIE: Shall I try to find the words for you?

ARTHUR nods.

BARRIE: You're thinking about them now, about the future. You wonder once you've gone what'll become of them.

ARTHUR nods.

BARRIE: You look at me and you feel apprehension.

ARTHUR nods.

BARRIE: For you don't think I'm a good man. For you think I'm closed and cold. For you think my sentimental attachment to your boys is unnatural in ways you can't fathom, and maybe you could if you were a more learned fellow. But in your heart you feel it's not right.

ARTHUR nods.

BARRIE: Still you hope that your boys are strong enough to stand on their own two feet and be the fine young men they are going to be, no matter what I do.

ARTHUR nods.

BARRIE: But now we're up against it and we can't do things by halves. This room will be closed and shuttered soon, and no one will come in... And what becomes of the boys? Who's to pay for school? Who's to keep up the house and staff? ... Who's to be their father now?

ARTHUR nods.

BARRIE: Are you giving them to me, Arthur?

Beat.

ARTHUR nods.

BARRIE: Free and clear?

ARTHUR nods.

BARRIE: Would you say it?

ARTHUR: Yes.

BARRIE: Yes, what, Arthur? I need you to say it. I'm so sorry. I must hear it.

ARTHUR: My boys...my boys...my boys...are yours.

Beat.

BARRIE: Peter, take your father out. Mark him now. That's a good man there. You'll rarely see his like, and never his better.

PETER PAN leads ARTHUR away.

PETER watches BARRIE.

PETER: What did he feel? He had got exactly what he wanted, but he wasn't triumphant. He wasn't crowing like Peter Pan over the body of Hook. Maybe grown ups don't crow.

ALICE: What do you feel?

PETER: Like I turned the first page of a book.

ALICE: What's the book called?

PETER: The Morgue... I don't run from the tears. I know that's part of life. Not the crocodile tears of a fairy story, but genuine mourning... <u>Anguish</u>... Shall we go on? There's more.

ALICE: No. We needn't.

PETER: Alice in Wonderland is bolder.

ALICE: She was younger.

PETER: More resilient?

ALICE: More uncaring.

PETER PAN: *Wendy, when you are sleeping in your silly bed you might be flying about with me!*

ALICE*: Ah, the dear old days when I could fly!*

PETER PAN: *Why can't you fly now?*

ALICE: *Because I am grown up, dearest. When people grow up they forget the way.*

PETER PAN: *Why do they forget the way?*

ALICE strokes his hair gently.

ALICE: *Because they are no longer gay and innocent and heartless.*

PETER: *(To BARRIE.)* … If only that were true. I wasn't heartless. I felt everything too much.

BARRIE: You didn't know yourself as boy.

PETER: Of course I did.

BARRIE: No, you remember yourself as you are now, only smaller.

PETER: It was my life, I remember it.

BARRIE: You weren't the man you are.

PETER: And I was heartless?

PETER PAN: I'm not heartless.

BARRIE: You were never one to cry.

PETER: What does that mean?! What does that matter?!

PETER PAN: Crying isn't for pirates!

PETER: Not like I didn't feel anything.

ALICE: But did you feel enough?

PETER PAN: If I'm sad on Monday I never remember it on Tuesday, so why bother in the first place?

PETER: God, it's all I can do nowadays to keep from crying! Sometimes I think I'll go mad from all the tears. Like a ridiculous little girl… *(To ALICE.)* … Like you, drowning in a pool of your own tears!

ALICE: Not me. Alice.

ALICE IN WONDERLAND: Me?

BARRIE: This makes me very sad, Peter.

PETER: Good, you deserve to be! I don't mean that.

BARRIE: At the grave of your father I looked over the faces, the five of you… And you, Peter, cheeks dry, so stoic… Beautiful and wounded.

PETER: As beautiful and wounded as Michael?

BARRIE doesn't respond.

PETER calms down.

PETER: I wonder... Was I old enough to understand what death was? Things go away and don't come back? That made no sense. Peter Pan always came back. A tap at the window and there he was. That's what you taught me, Uncle Jim.

BARRIE: Not a tear for your father.

PETER: I've cried about it since.

BARRIE: <u>Or your mother</u>.

Difficult beat.

PETER explains to ALICE:

PETER: It was only three years after my father died. My mother fainted one afternoon, right there in the parlor, her arm fell, I remember that, fell to the carpet and stretched out towards me. Her maid cut her stays so she could breathe. I don't remember if the bone was iridescent, sorry. In any event, we forgot all about it... And then it happened again... It was cancer. Again.

ALICE: I am so sorry...

PETER: We were cursed. Like something from one of his melodramas: the family curse... At least she went quickly, with minimal disfigurement, which she would have found intolerable... And from then on, we were his.

BARRIE: My boys.

PETER: To exploit.

PETER PAN: To immortalize!

PETER: What child wants to be immortal?!

ALICE: What child thinks he isn't?

PETER: Did you think you were going to live forever?

ALICE: I still do.

PETER smiles.

ALICE: May I ask a personal question?

PETER: You seem incapable of asking anything but.

ALICE: Were you interfered with?

PETER: Molested you mean? By Barrie? No, nothing like that… Not <u>physically</u> anyway.

This strikes a chord with her.

PETER: To be asked to reckon with things beyond your years? Is that to be molested? … To be fixated upon. To be kept too close.

ALICE: To be forced into feelings you don't understand. To be spoken to about emotions too strong for youth, too deep for childhood.

PETER: To always disappoint because you don't love back enough.

PETER PAN: You love back as much as you can, that's all.

ALICE: To be the dream child in a dream you couldn't possibly comprehend.

ALICE IN WONDERLAND: Nor should you, because you're only a child.

ALICE: <u>Being made to grow up too soon</u>.

PETER: Yes. That's it. We've arrived.

ALICE: Where?

PETER: At our story… At Peter and Alice.

ALICE: The love story?

PETER: Partly… And partly that other book. The endlessly painful one with no happy ending.

ALICE: Honestly! I gather it's fashionable among young people to be dreadfully grim and depressive, you wear it as a badge of pride, but it's rather a bore. Now I've had my

share of difficulties, but I've always carried on with some hope.

PETER: "Difficulties" you call it? That's a comfortable euphemism, like finding another word for cancer.

ALICE: Loss? <u>Death</u>? Is that what you want to hear?

PETER: That's what it is.

ALICE: I'm not afraid of the words, but I don't luxuriate in them.

PETER: Is that what I do?

ALICE: I think so.

PETER: That's just who I am.

ALICE: It's indulgent.

PETER: Sorry.

ALICE IN WONDERLAND: Stop arguing, it's too boring!

PETER PAN: Or start fighting at least! Who has a sword?

PETER: *(Continuing to ALICE.)* All right then, let me ask you: these feelings of loss, do you remember the very first time you felt them? … And were you the same person after?

ALICE: How can I remember something like that? It's too vague.

ALICE IN WONDERLAND approaches.

ALICE IN WONDERLAND: Now she's telling stories.

PETER PAN: I love stories! Are there Indians?

ALICE: I'm not telling stories.

ALICE IN WONDERLAND: Of course you are! You remember perfectly.

PETER PAN: And pirates and monsters and ships and battles and motorcars and balloon trips and undersea creatures and…!

ALICE IN WONDERLAND: The darkroom, silly!

This stops ALICE.

CARROLL: <u>Alice, keep still</u>!

ALICE IN WONDERLAND: Don't you remember the darkroom?

PETER: Tell me.

ALICE: No.

CARROLL: <u>You must stay exactly as you are</u>!

PETER PAN: I love stories more than anything. Wendy told stories. And then she grew up.

PETER: Tell me a story, Wendy.

ALICE looks at him. So be it.

ALICE: My sisters and I had gone to Reverend Dodgson's studio to be photographed. This was not uncommon; we'd done it many times…

CARROLL: You must hold still, Alice!

ALICE poses for a picture. CARROLL is photographing her; a painstaking and elaborate process in 1863.

ALICE IN WONDERLAND strikes an identical pose.

CARROLL goes about the minutiae of his task.

ALICE: I smell the chemicals still… Bromide and chloride dissolved to make the solution for the negative… Then like magic out comes the polished glass plate, which had to be perfectly clean, I've never seen anything cleaner, no dust, no imperfections, like the skin of a baby, fresh like youth, I don't know like what, like <u>innocence</u>!

PETER: *(Laughs.)* Oh God!

ALICE: Don't make me laugh, I'm supposed to be standing still… Then he carefully brushed the solution on the glass with a darling little sable brush I always coveted.

ALICE IN WONDERLAND: *(Re: sable brush.)* Oh! It's ravishing!

CARROLL: Don't move! Just a little longer.

ALICE: Then he whisked the plate into the darkroom to dip it into the silver nitrate and then so gingerly back into the camera, like a surgeon those hands, those soft hands, then a final adjustment to the lens... *(To CARROLL.)* ... I want to move.

CARROLL: You'll ruin it all.

ALICE: Lorina's making faces!

CARROLL: She's a very silly goose and you're my Queen! Hold still, Queen Alice!

ALICE: Then the moment! Hold your breath! Lens cap off. Time... stops.

Everyone holds their breath.

A few frozen moments.

ALICE: Lens cap on! Move!

CARROLL: Come with me, Alice! Double quick!

CARROLL and ALICE hurry into the darkroom.

Light almost disappears. They are now lit by the muted glow of the darkroom.

ALICE: Into the darkroom! Shut the door. Like being lost at the bottom of the ocean, submerged in the deep dark.

PETER PAN: With the sea creatures!

ALICE IN WONDERLAND: Are you happy now?

ALICE: The plate eased into the solution of acid and sulphate...back and forth, back and forth... What could be more thrilling than to see the negative gradually take shape, yourself gradually take shape?

ALICE IN WONDERLAND: There you are... But in reverse, topsy-turvy, like everything in Wonderland. You and not you.

ALICE: Even now, all these years later, the odor of certain chemicals brings me back there, to that room, on that day… This was the second and final time we were alone.

CARROLL: Look, I'm starting to see you…

ALICE: Can't my sisters watch?

CARROLL: The door's shut now. We'd ruin everything… There's your face emerging…

ALICE: I don't know that I like my expression. I seem a bit dour.

CARROLL: You seem precisely you, precisely now. It's this moment, captured forever, never changing.

ALICE: Only it's that moment back there and I've already changed.

Beat.

CARROLL continues to develop the picture.

CARROLL: Do you think you'll change much as you get older?

ALICE: I should hope so. Who wants to remain the same forever?

CARROLL: Do you think you'll remember me?

ALICE: I don't know.

CARROLL: Ah.

ALICE: I'm bound to meet lots of people in my life, and some very memorable. I should think you would be one of the most memorable, but I can't say for certain.

CARROLL: It's a fleeting time, this we have… When you're like you are now.

ALICE: You mean when I'm eleven?

CARROLL: P-p-p-partly that.

ALICE: Is that why you take so many photographs? So you won't forget?

CARROLL: I'll never forget. But you will. You'll move on to your adulthood of ways and means, of fancy dress balls and that bluff good fellow you're going to marry, all the things that will make up the sum of your life. And a happy life it will be I know... But no reason to be sad for me. For I have this, don't I?

ALICE: But that's not me... I know that's not really me.

Beat.

He continues to work on the picture for a moment.

CARROLL: You're coming along nicely... You see how you are? ... Never growing older, never growing wiser... Like in my heart.

ALICE: *(To PETER.)* I didn't understand fully.

PETER: But you understood enough.

CARROLL: I have a wish for my child-friends. Do you know what it is?

ALICE: That we always stay like we are. But I don't understand why.

He stops.

He considers whether to go on.

CARROLL: In the place called Adulthood, there's precious few golden afternoons. They've gone away to make way for other things like business and housekeeping and wanting everyone to be the same, just like you, all the lives lived in neat hedgerows, all excess banished, all joyous peculiarities excised. It's grim and shabby. There are no Mad Hatters and there are no Cheshire Cats, for they can't endure the suffering of the place.

ALICE: Please stop...

CARROLL: That's the p-p-p-place called Adulthood... I'm there now. You'll be there soon enough. And you'll never leave... But here and now, in this room, and on this glass plate, and in the story I'm writing, you'll never be there...

And you'll never be hurt. And you'll never be heart-sick.
And you'll never be alone… You will be beloved.

ALICE is near tears.

ALICE: I have to go.

CARROLL: It'll ruin the picture.

ALICE: May I go?

Beat.

CARROLL: Go, Alice.

*She quickly leaves the darkroom, moves away from CARROLL, trying
to recover her equilibrium.*

PETER PAN: *(Disappointed.)* That was an awful story!

ALICE IN WONDERLAND: Shhh.

ALICE looks at CARROLL.

ALICE: Poor wounded soul. Everlastingly tormenting himself
about a sin that didn't exist, but was completely true… I
think the photographs were just a way to give him a safe
framework to explore some unknown and dangerous
landscape. He transformed his desires into paper and silver
nitrate. What could be more innocuous?

PETER: Perhaps we all do that when we grow up. Find safe
ways to make dangerous trips.

PETER PAN: Generally the pirate lagoon is more dangerous
than the Indian camp.

ALICE IN WONDERLAND: Except when it's the other way
around.

PETER PAN: Exactly! … It'll be dark soon. Help me find some
wood for a campfire.

PETER PAN and ALICE IN WONDERLAND assemble a campfire.

ALICE: I went home that day and told my mother of our
conversation in the darkroom. What I could understand of
it… She didn't let us see him after that. She made me burn

all his letters. All that special purple ink he used, up in flames... A year later I received the manuscript of "Alice's Adventures Underground" in the post. In his own hand, with his own drawings... I never thanked him.

PETER: And you never saw him again?

ALICE: Much later. When I was grown and married. We had tea with my sister Lorina... We were cordial strangers... The golden afternoon was over. I thought it was going to be endless. But it was as quick as the beating of a dragonfly's wing.

PETER PAN and ALICE IN WONDERLAND ignite their representation of a campfire.

ALICE and PETER are drawn toward it as well...it suggests CARROLL's letters burning, the smoke drifting up.

They all huddle by the fire, it's warm and intimate... We're in a beautiful representation of Neverland now.

ALICE: Lord, as many days as are left to me, I'll never forget those letters burning... It was the cruelest thing I'd ever seen: all the lovely words, all his heart's devotion, <u>gone.</u> As if they never existed... It was the first time I realized that things don't always stay the same... *(she watches the smoke drift away)*... There it goes; into the vapors... Should life really be that delicate?

PETER: Life was supposed to be strong and hearty. Like a pirate.

ALICE IN WONDERLAND: But sometimes it's gossamer, like Tinker Bell.

PETER PAN: Like a Mock Turtle's tear... It gets cold at night in Neverland. He didn't write about that.

PETER PAN shivers, a little chilled.

PETER unconsciously puts his arm around him.

ALICE IN WONDERLAND: There is no night in Wonderland. No one sleeps much.

PETER PAN: The Dormouse sleeps… The Mad Hatter I think.

ALICE: Would the Mad Hatter dream about being sane?

PETER: Believe me, he would.

ALICE: And Peter Pan, what would he dream of?

PETER PAN: Mother.

ALICE takes in the lovely fire, the stillness, the beautiful nighttime setting.

ALICE: It's enchanting here.

PETER: Oh yes…

He wanders forward, holding PETER PAN by the hand.

PETER: Neverland is enchanting; it always was to me… I remember the first time I saw the play. I thought it was all real, you remember?

PETER PAN: Yes.

PETER: I thought you were real and Captain Hook was real and the painted flats were endless vistas.

PETER PAN: Aren't they?

PETER: If they were you would have flown off forever, never to be seen again, onto the next…enchantment.

He leaves PETER PAN and steps forward alone.

PETER: I wanted to live there, Mrs. Hargreaves… From my box, the first time I saw the play, my brothers at my side, Uncle Jim busy somewhere backstage, I saw Neverland come to life. It was real. It was real… And it was so beautiful… I could fly.

PETER PAN: You can.

PETER: After the performance Uncle Jim took us backstage. It was a mad bustle, even that was thrilling. I mean I knew it wasn't <u>actually</u> real, I knew they were all actors, and we were in a theatre… But I needed to know if this place existed, if it were somehow <u>true</u>, even though it wasn't real.

So as the party was going on and everyone was celebrating I wandered onto the stage by myself. Just me... How large it was... I saw the painted backdrop of Neverland. The pirate ship...the wooden moon... And I closed my eyes and spread my arms... And it was true.

ALICE: Through the looking glass...

PETER: For a moment... Then I opened my eyes and heard the party, and Uncle Jim calling me, and my brothers laughing... And life went on.

ALICE: But it was true.

PETER: When I was a child.

Beat.

ALICE: So was Wonderland. I could chart every foot of it. But the depths of Mr. Carroll, those anguished letters... Those were the Jabberwocky, the dangerous, impenetrable things.

PETER: Uncle Jim wrote letters too, compulsively, hundreds of them. He poured out his heart to us.

ALICE: He did love you.

PETER: Oh yes. But it was a melancholy kind of love, because it was always entwined with an inevitable sadness. He knew we were going to grow up and leave him alone... First George to Eton and Oxford and then Jack and then me and then Michael... Michael, who always set his truest course...

BARRIE: Dear Michael, The Adelphi House is haunted tonight. I think your brother's namesake is tapping at the window in search of his shadow. Sometimes I feel I'm in search of my shadow as well, but he's busy with his mannish pursuits at Eton...

PETER: They wrote to each other every single day from the time Michael went to school... Mountains of letters, oceans of words... Sometimes the separation was too much for

Uncle Jim and he would go to Eton and stand on the fringes of the playing fields, watching him from a distance.

ALICE: Like a lover.

PETER: Like a sailor's wife waiting for her husband to return from the sea.

ALICE: And the letters…and the devotion that inspired them… all gone now…like a Mad Hatter's dream…smoke and ash…a little dust in the corner of the box you keep your toys.

She looks at PETER.

ALICE: It is a love story, as you promised.

ALICE IN WONDERLAND hops up, breaks the mood, turning to PETER PAN:

ALICE IN WONDERLAND: Come here, boy! Dance with me.

PETER PAN: No!

ALICE IN WONDERLAND: Why not?

PETER PAN: Because you're very ugly.

ALICE IN WONDERLAND: No I'm not.

PETER PAN: Because I've many important things to do. There's a staff meeting this morning and I've a luncheon appointment at Simpson's.

ALICE IN WONDERLAND: If this is a love story there has to be dancing.

PETER PAN: Not with me!

ALICE IN WONDERLAND: Don't you want to fall in love?

PETER PAN: When I'm old and practically dead. And since I'm immortal, that's never, so there.

He stomps away.

ALICE IN WONDERLAND is hurt.

ALICE steps forward and offers her hands.

ALICE IN WONDERLAND looks at her, smiles and takes her hands.

Gentle music as they dance.

REGINALD (REGGIE) HARGREAVES enters crisply, like a fresh breeze. He's a good-looking, athletic, hearty young man. It is 1879.

REGGIE: Alice Liddell, you promised <u>me</u> the next dance!

ALICE turns to him, surprised.

REGGIE: What are you staring at? I've been waiting over there all night like – what? – a Labrador or some other sad sort of whathaveyou. Come on! You won't be so churlish as to renege!

ALICE: Reggie…?

ALICE IN WONDERLAND happily hands ALICE to REGGIE.

REGGIE: Before we dance, I've got to say something to you. What I mean is…well… Let's clap hands and make a go of it! Lord, what an ass I am! Sorry – didn't mean to say "ass." Blast it all! Sorry – didn't mean to say–! Look what you do to me, Miss Liddell!

She laughs. He's charming in his inarticulate awkwardness.

REGGIE: At least I made you laugh, that's something.

ALICE: You could always make me laugh.

REGGIE: I'm an absurd fellow, no use hiding the fact, as if I could, you know me inside and out, those eyes of yours just – ah, what's the word?! – Look here! I'm no scholar, that's God's truth. But I'm a more than commonly good shot and a good bat and a really top-notch spin bowler, I can speak some French, I've got an income and the estate will be wholly mine, and I'm nowhere near good enough for you, I think you might break if I touch you, not that I would ever touch you, with too much vigor I mean! But, but– <u>Blast</u>!

He peters out.

REGGIE: I've lost the words.

ALICE: Shall I find them…?

REGGIE: Please.

ALICE: I wish you to be my wife.

REGGIE: That's the second part. The first is this… *(He kneels.)* … I love you. I shall always try to be worthy of you… Say you will be my wife, Miss Liddell.

ALICE looks at him, but doesn't answer.

ALICE IN WONDERLAND: What are you waiting for?!

ALICE: At the moment… I hesitated.

ALICE IN WONDERLAND: But he's so handsome!

PETER PAN: *(To ALICE IN WONDERLAND.)* That's the sort you like: thick-headed kneeling gallants. I'll never kneel to anyone!

PETER: Why did you hesitate?

ALICE: I suddenly saw it as a compromise. I would be giving up too much… It was like I was my mother, watching Lorina put on her first corset: resignation to something vast, and helpless to change it.

REGGIE slumps. He's disheartened.

REGGIE: Not much of a lark anymore, is this?

ALICE: Reggie –

REGGIE: I'm terribly sorry, Miss Liddell. Forgive me… *(He stands, proceeds with some difficulty.)* … I know you've been raised with certain expectations. You've been around scholars all your life; men of learning and polish. Surely that's what you always imagined for yourself… And I know myself, that's not me, never will be… I had hoped, I see now foolishly, that there was more to life.

Beat.

REGGIE: I'll bid you goodnight.

He starts to go.

ALICE IN WONDERLAND: Wait!

He stops.

ALICE IN WONDERLAND: *(To ALICE.)* Don't let him go!

ALICE: I wanted to be a writer when I was little, did you know that? I wanted to be an independent woman, like Jane Austen.

ALICE IN WONDELAND: He's a fine man and he loves you!

ALICE: Or a poetess.

ALICE IN WONDELAND: Look at him.

ALICE: I wanted so much.

Beat.

She finally looks at REGGIE.

ALICE: I will be your wife.

REGGIE: Do you mean it?

ALICE: Heart and soul.

REGGIE springs to her.

REGGIE: God, this is splendid! Dodged a bullet there! Now I've got to talk to your father, should have done that first. Blast! Got it all back-assed – sorry!

He kisses her, ecstatic, and bounds away.

ALICE is almost overcome.

She touches her lips.

Music builds to a glorious waltz.

ALICE: We were married at Westminster Abbey… After the wedding he took me home. The only house I ever lived in outside my father's.

REGGIE: Place is called Cuffnells, damned if I can tell you why, been the family estate back to good old King so-and-so-the-fourth. Some of the richest Hampshire earth going;

plant a stone and it'll grow… Let me present you. Shan't bother with the names, can't remember 'em myself half the time…

He introduces the parade of servants. ALICE is in awe of the grandness of the house and the lifestyle.

REGGIE: Butler, under-butler, cook, under-cook, footman, other footman, boot boy, coachman, groom, under-groom, head gardener, topiary gardener, under-gardener, and your seven pretty maids all in a row: ladies maid; scullery maid; laundry maid; kitchen maid; other kitchen maid; under-housemaid; other under-housemaid.

PETER PAN: *(To ALICE IN WONDERLAND.)* Say that three times fast!

REGGIE: You're home, Queen Alice!

A spirited waltz is heard. It's a glittering ball at Cuffnells.

ALICE: Who says Wonderland doesn't exist? Who says there are no happy endings? Had I not found mine? … Days and nights of balls and fetes and tableau vivant on the lawns, riding to the hounds, into town for theatre and exhibitions, all those golden things that don't exist anymore, like this music, like the waltz… And then the boys! Best of all, our boys… Alan and Rex and Caryl… Our three sons growing strong and true…

PETER PAN: *(To ALICE IN WONDERLAND.)* Oh, all right! Stop looking at me with those great cow eyes!

He dances with ALICE IN WONDERLAND.

ALICE dances with REGGIE.

BARRIE dances with CARROLL.

Even PETER is charmed by the music and swirling couples.

ALICE: And if as he aged he grew more conservative in his views, tending to be a little stern, a little mean…and if he never read a book, but played golf instead…and had clumsy affairs with those seven pretty maids…and

I was the tiniest bit bored by it...by everything...and I would never be Jane Austen...and I took rather too much laudanum to sleep at all... Well, if that's growing up it held no heartbreak for me. It was not Mr. Dodgson's place called Adulthood, that darkroom horror... It was my life, and in the end my boys made it all worthwhile.

PETER: Crawling over your lap like puppies.

ALICE: <u>My children</u>. One more marvelous than the last... Alan and Rex and Caryl...

PETER: George and Jack and Peter and Michael and Nico...

CARROLL: Alice and Lorina and Edith...

BARRIE: Wendy and Michael and John...

ALICE: How could it ever end?

PETER: If we could only stay here forever.

ALICE: Stop the clock.

PETER: Close the book.

ALICE: Just one more endless summer.

The music suddenly ends as PETER PAN breaks the mood.

Boldly, to ALICE IN WONDERLAND:

PETER PAN: I'll never understand grown ups!

ALICE IN WONDERLAND: Nor I. They have perfectly good breast of guinea hen in front of them, they only want mutton.

PETER PAN: Any time they're happy, they can't wait to be sad.

ALICE IN WONDERLAND: Never here and now, always there and later.

PETER PAN: Always looking at the clock.

ALICE IN WONDERLAND: Looking over their shoulder.

PETER PAN: Then back at the clock.

ALICE IN WONDERLAND: Time for this, time for that, never time for "well, here we are, isn't it glorious?"

PETER PAN: Go to a party, look at the cake, long for the cake, reach for the cake–

ALICE IN WONDERLAND: Don't eat the cake.

PETER PAN: I love cake.

ALICE IN WONDERLAND: I love pie.

PETER PAN: He loves gin.

ALICE IN WONDERLAND: And have you noticed – they're always waiting for it to rain?

PETER PAN: They carry umbrellas on the sunniest days – which is dangerous because if you're attacked you need one hand for your cutlass and the other for your pistol.

ALICE IN WONDERLAND: Everyone knows that!

PETER PAN: Maybe they forgot?

ALICE IN WONDERLAND: Sometimes they don't even have pistols.

PETER PAN: What do they do when the Indians attack?!

ALICE IN WONDERLAND: They're always forgetting.

PETER PAN: When they're not always remembering.

ALICE IN WONDERLAND: So there's never time for tarts.

PETER PAN: Or cutlasses or kites.

ALICE IN WONDERLAND: Or croquet!

PETER PAN: Or dancing to the pipes in the deep, dark woods!

ALICE IN WONDERLAND: Like they used to.

PETER PAN: I hear the pipes all the time!

ALICE IN WONDERLAND: She wasn't always like this, mind, like she is now. She was <u>wicked</u> in her day.

PETER PAN: The old lady? Not likely!

ALICE IN WONDERLAND: That darling little sable brush? Pinched it.

PETER PAN: Good for her!

PETER: You didn't!

ALICE: Still have it!

ALICE IN WONDERLAND: And she knew men. Grown up gentlemen I mean, in her day. A lot of them.

ALICE: *(Unpleasantly shocked.)* Oh.

PETER PAN: He carries a flask and drinks all the time.

PETER: *(Quickly to ALICE.)* I told you that.

PETER PAN and ALICE IN WONDERLAND grow increasingly revelatory, but are entirely without rancor:

ALICE IN WONDERLAND: She took lovers and then grew bored.

PETER PAN: His children are embarrassed by his drinking.

ALICE IN WONDERLAND: She doesn't love all her sons the same.

ALICE: That's not true!

ALICE IN WONDERLAND: 'Tis.

PETER PAN: He's a great big liar too. Betrays his wife regularly, pretends she doesn't know.

ALICE IN WONDERLAND: Does she know?

PETER PAN: Of course she does! He doesn't care.

ALICE IN WONDERLAND: She despises tradesmen and blackies and chinkies and pretty much anyone who's not her.

PETER PAN: He still lives on Barrie's money.

ALICE IN WONDERLAND: She bites into her pillow and cries every night.

PETER PAN: Barrie paid for the publishing house.

ALICE IN WONDERLAND: But thinks <u>other people</u> crying is weakness.

PETER PAN: Hates him, but takes the money.

ALICE IN WONDELAND: She thinks about killing herself.

PETER PAN: He's hit his children.

ALICE IN WONDERLAND: She looks at the bottle of laudanum and wonders.

PETER PAN: He fears he's going mad.

ALICE IN WONDERLAND: She's forgotten how to play croquet.

PETER PAN: <u>He's forgotten how to fly</u>.

ALICE tries to stop the scene:

ALICE: Stop this.

PETER: Mrs. Hargreaves…?

ALICE: We need to stop this.

ALICE IN WONDERLAND: You can't tell us what to do.

PETER PAN: Never could.

ALICE: We need to stop right now!

ALICE tries to escape. But PETER PAN and ALICE IN WONDERLAND block her way; it's like a game to them. She is increasingly distraught.

ALICE IN WONDERLAND: Is this a game?

PETER PAN: What are the rules?

PETER: *(Concerned.)* Calm down, please…

ALICE IN WONDERLAND: Maybe there are no rules!

PETER PAN: Even better!

ALICE IN WONDERLAND: And then of course she sent her sons to the war.

The music and lighting change.

It is now 1915... The trenches of France...young men off to war... perhaps the distant sound of battle.

This affects ALICE and PETER strongly.

PETER PAN is delighted:

PETER PAN: Oh well done! Now we're going to have some <u>action</u>! No more dancing! Time for some fisticuffs, my lady!

ALICE IN WONDERLAND: Boys! You're only happy with dirt on your knees and blood on your nose.

PETER PAN begins to play his pipe. The tune eventually turns melancholy.

ALICE: Is there a moment you grow up? … Not an evolution, not the passage of a summer or a year. <u>A single moment</u>… Perhaps it was when my boys first put on their uniforms. The moment it all changed.

CARROLL: You must hold still, Alice…

ALICE: When everything fell to pieces.

PETER: Like Humpty-Dumpty.

ALICE: Cracked apart.

PETER: Into a thousand pieces.

BARRIE: To fight, and fly, and fight again…

ALICE: The whole fiction of my comfortable life.

PETER: Never to make sense again.

ALICE: <u>Never</u>.

PETER PAN: I don't know that word.

ALICE IN WONDERLAND: It's a twelve-year-old word in truth.

PETER: Once the war came, everything you thought you knew…

ALICE: <u>Was wrong</u>.

PETER: The answer is yes. There's a moment. One day I killed a man, you see. In the deep, dark woods. The forest was choked up with bodies and mud. I was knee deep in it. If you step on a body you can split the stomach and release the gasses, and the stench is appalling, so I was looking down, trying not to step on any corpses, I looked up and the fellow was suddenly just there in front of me and I shot him…

ALICE: I sent my boys off to the war. So handsome in their uniforms. So smart they were.

PETER PAN: *How clever I am. Oh, the cleverness of me.*

PETER: I didn't even know if he was a German, his uniform was so muddy. I just shot him in the chest. I was so scared… I sat down on the ground and watched him die. I knew he was dead when he didn't move, but the fleas did. They crawled away from him, like they knew, like they were abandoning him, it was so sad… I sat on the ground and I watched him die… Then I went mad.

ALICE IN WONDERLAND: *But I don't want to go among mad people!*

PETER PAN: *Oh, you can't help that. We're all mad here.*

ALICE IN WONDERLAND: *How do you know I'm mad?*

PETER PAN: *You must be. Or you wouldn't have come here.*

PETER: Shell-shock they call it, but it wasn't a shock. It was a numbing. I felt absolutely nothing as my life cracked open and spilled out of my head, started pooling around my feet… I was seconded home, in shame. I went to asylums. Light bulb never off: suicide watch. Rubber mouth guard so I wouldn't bite my tongue off… But my life was still pooling around my feet. I couldn't stop it. I was all cracked open.

ALICE: I saw my boys go away to war… And everything that had ever happened in my life led me to believe they would return.

ALICE waits.

ALICE IN WONDERLAND goes to ALICE, wiser than her years:

ALICE IN WONDERLAND: *That was the last time the girl Wendy ever saw him. For a little longer she tried for his sake not to have growing pains… But the years came and went without bringing the careless boy; and when they met again Wendy was a married woman, and Peter no more than a little dust in the box in which she kept her toys…*

The moment has come.

It's inevitable.

PETER PAN: Third Battalion barracks. Company C. 10th May 1915… Officially reported that Captain Alan Hargreaves killed in action 9 May 1915 please to convey deep regret and sympathy of their Majesties the King and Queen and Commonwealth government in loss that parents have sustained in death soldier reply paid Colonel Boscombe.

ALICE is shattered.

PETER PAN: … officially reported that Second Lieutenant George Llewelyn Davies killed in action 15th March 1915 please to convey deep regret and sympathy…

PETER: *And all the king's horses, and all the king's men…*

PETER PAN: … officially reported that Captain Rex Hargreaves killed in action 25th September 1916 please to convey deep regret and sympathy…

ALICE is going to collapse.

ALICE IN WONDERLAND quickly brings a chair.

ALICE sits.

She is lost in herself.

PETER as well.

ALICE IN WONDERLAND wanders into the no-man's-land of the war.

A beat as she takes in the desolation…and then turns to CARROLL *tenderly:*

ALICE IN WONDERLAND: In the place called Adulthood there are no Cheshire Cats…for they can't endure the suffering of the place.

CARROLL steps to her.

Beat.

He bows deeply.

CARROLL: Queen Alice.

He begins to leave the stage, but…

ALICE IN WONDERLAND: Mister Dodgson…

He stops.

She bows to him.

He is touched by the gesture.

He then leaves the stage, and the story.

Beat.

MICHAEL DAVIES enters. He's a beautiful and poetic young man, fragile.

ALICE IN WONDERLAND: My, he's handsome… Maybe he'll dance with me.

PETER PAN: He won't.

ALICE IN WONDERLAND: Who is he?

PETER PAN: Michael… My shadow.

PETER: *(To BARRIE.)* You used to stand on the fringes of the playing fields, watching him…

BARRIE: I cannot picture a summer day that does not have Michael skipping in front. That is summer to me…

PETER: Uncle Jim… White or black?

Beat.

BARRIE: Black.

BARRIE and PETER sit, play chess. MICHAEL hovers near them, he's nervous about something.

They are in BARRIE's palatial flat at the Adelphi Terrace, where MICHAEL lives when he's not at Oxford. It is 1921.

MICHAEL: Uncle Jim, I'd thought I'd bring my friend Buxton up to town next weekend. I think you'd like him.

BARRIE: I need a pipe.

MICHAEL: Let me.

He cleans, prepares and fills BARRIE's pipe during the following. It's quietly domestic.

PETER: Your move.

BARRIE: You're thinking strategically.

PETER: Played a lot in the war. And not too much else to do in the nutter hospital.

BARRIE: I wish you wouldn't talk like that.

PETER: Sorry, "sanitarium." Oh yes, that's much better.

MICHAEL: *(Continuing to BARRIE.)* I know you don't always approve of my mates from school but Buxton's your sort, not a playwright I mean, but <u>exceptional</u> really. Sort of a poet, I guess.

BARRIE: Do what you wish, Michael.

MICHAEL: That means you'd rather I didn't.

BARRIE: It means nothing of the sort.

PETER: A poet?

MICHAEL: Sort of a poet, yes.

PETER: What sort?

MICHAEL: I meant he writes poetry.

BARRIE makes a move on the chessboard.

PETER: You're not thinking.

He quickly takes a piece.

They play for a moment as MICHAEL continues to prepare BARRIE's pipe.

BARRIE: *(To MICHAEL.)* Only I see you so rarely.

MICHAEL: So you'd rather I didn't bring him?

PETER: Oh just bring him!

MICHAEL: Not if Uncle Jim doesn't want me to.

BARRIE: I've no hold on you, Michael, you're twenty years old, do as you like.

MICHAEL: Oh God!

PETER: Just bring him!

MICHAEL: I want you to meet him. It's important to me.

BARRIE: Why?

MICHAEL: Because he's my friend.

BARRIE: Your "poet" friend.

MICHAEL: I suppose.

BARRIE: You've a lot of friends.

MICHAEL: Do I?

BARRIE: And now a "poet."

MICHAEL: Yes, I–

BARRIE: What next, I wonder?

PETER: *(To BARRIE.)* Don't.

MICHAEL: Look – It's because I – I want you to know him. It means something to me that you know him.

BARRIE: What are you trying to say?

MICHAEL: We've talked about going away, that's all.

BARRIE and PETER stop.

PETER: Going where?

MICHAEL: France. Paris… To study painting.

BARRIE: You'll do no such thing.

PETER: Painting?

MICHAEL: Yes! Painting! I want to study painting. Buxton says I've got some talent and we ought to chuck it here and go off to Paris for a while and make a go of it.

BARRIE: I won't hear a word of it. You're being childish.

PETER: Stop it.

BARRIE: *(Ice.)* I'll speak my mind in my own house if you'll allow me that… *(To MICHAEL.)* … You've got to finish your studies and be a practical man. You've got to grow up, lad. Do you think I'm going to pay your tradesman's bills forever?

This strikes like an arrow.

BARRIE: I've no interest in pictures myself. Don't see the point of them. Lot of cloud-spinning, I've always thought. But if that's what you want to do, live that sort of life… Bohemian… Is that what you'd call it? … Michael… Bohemian?

MICHAEL: I don't know.

BARRIE: Whatever you call it, who am I to stop you? Do what you will. I don't need to meet this "poet" of yours.

MICHAEL is near tears.

BARRIE: I'll have my pipe now.

MICHAEL hands him his pipe and quickly moves away from the scene; upset.

PETER PAN impulsively goes to comfort him. The lights change as they move away, isolated in their togetherness.

ALICE: *You ought to be ashamed of yourself, said Alice, a great girl like you to go on crying in this way! Stop it this moment, I tell you...*

PETER PAN: *But she went on just the same, shedding gallons of tears, until there was a large pool all around her, and reaching half down the hall...*

ALICE*: Her first idea was that she had somehow fallen into the sea...*

ALICE IN WONDERLAND: *However, she soon made out that she was in the pool of tears that she had wept...*

MICHAEL: *I wish I hadn't cried so much, said Alice. I shall be punished for it now, I suppose, by being drowned in my own tears.*

BARRIE: Dear Arthur, Every year since your death I have written to tell you of your sons and their progress through life. I've tucked the letters away into a neat bundle, tied with a ribbon. Never did I think I could have a more difficult composition than that of 1915 when we lost George...

Light like rippling water begins to isolate MICHAEL and PETER PAN.

BARRIE: But this year, in the month of May, 19th of the month, Michael and his friend Buxton went to Sandford Pond, a few miles south of Oxford. Perhaps you recall it? It's a place where many of the boys swim...

PETER: I went there later, Mrs. Hargreaves. The water is placid.

BARRIE: They stepped into the water together...

PETER: Witnesses saw two men holding each other, not struggling, quite still in the water...

PETER PAN: *The most haunting time to see the mermaids is at the turn of the moon, when they utter strange wailing cries; but the lagoon is dangerous for mortals then...*

BARRIE: The distance from bank to bank is too small for the question of swimming capacity to enter into it at all...

MICHAEL: *Two small figures were beating against the rock; the girl had fainted and lay on the boy's arms. With a last effort, Peter pulled her up the rock and then lay down beside her. He knew that they would soon be drowned...*

ALICE IN WONDERLAND: *Wendy was crying for this was the first tragedy she had seen...*

PETER PAN: *Peter had seen many tragedies; but he had forgotten them all...*

PETER: *The rock was very small now; soon it would be submerged...*

BARRIE: They were not struggling. They were not trying to save each other...

MICHAEL: *By and by there was to be heard a sound at once the most musical and the most melancholy in the world: the mermaids calling to the moon...*

BARRIE: Or maybe, Arthur, in the end they did save each other...

PETER: *Peter Pan was not quite like other boys; but he was afraid at last...*

ALICE: *A tremor ran through him, like a shudder passing over the sea...*

MICHAEL: *But the next moment he was standing erect on the rock again, with that smile on his face and a drum beating within him...*

PETER PAN: *To die will be an awfully big adventure!*

Lights change.

BARRIE stands in shock.

PETER is in his own thoughts.

ALICE has remained seated.

PETER: And you wonder I call it a <u>lie</u>? ... That play... That book.

ALICE: Oh yes, it's a lie.

PETER: Maybe there was a time I believed it, but life, Mrs. Hargreaves…

ALICE: Oh yes.

PETER: Peter and Alice… Shards of youth… I'm no more Peter Pan than you're Alice in Wonderland. We are what life has made us.

He looks to BARRIE.

PETER: Even he finally had to realize the same thing I have: the only reason boys don't grow up is because they die… Isn't that true, Uncle Jim?

Beat.

BARRIE: It is.

He leaves the stage, and the story.

PETER: There are no mermaid lagoons; there are still, deep waters where lonely boys drown themselves. There are no pirate captains; there are trenches and bullets and razor wire. We do not fly, Mrs. Hargreaves, nor could we ever.

PETER PAN: Speak for yourself!

PETER: Stop it.

PETER PAN: Don't you ever get tired of blaming me for your miserable life?

PETER: You're the glass that distorted everything.

PETER PAN: Honestly! I fly through the night, skip on the clouds, sing in the forest, fight me some pirates, what harm have I ever done you? If you're broken, you broke yourself. I won't even remember you tomorrow.

ALICE: You talk to him like he's real.

PETER PAN: I am real!

PETER: He's not.

ALICE: Hard to tell sometimes.

PETER: <u>Not for me</u>.

ALICE IN WONDERLAND: But then you think you're going mad.

PETER PAN: We're all mad here.

PETER: Be quiet!

PETER PAN: Someone get him his mouth guard.

PETER: He doesn't exist! – *(To ALICE IN WONDERLAND.)* – Neither do you! This is demented.

PETER PAN: You're the expert on that.

PETER: None of this is real.

ALICE: I wonder who's more real, Peter Davies or Peter Pan?

PETER PAN: Bully for her!

ALICE: In a hundred years no one will ever remember Alice Liddell. And no one will ever forget Alice in Wonderland… Now you tell me who's more real.

PETER: Mrs. Hargreaves… We can't live in a fantasy. <u>Reality may be hard, but it's all we have</u>.

ALICE IN WONDERLAND: *Wendy felt at once that she was in the presence of a tragedy…*

PETER: Maybe there was a time but… The war ditched me really, and then Michael's death. The nightmares are pretty unspeakable. You see, when I close my eyes I see them, my family…and I feel…<u>I feel they are waiting for me</u>. As if I would be <u>betraying</u> them if I didn't join them: for we are a family defined by our sadness… To this day I'm frightened to close my eyes, because when I do I see them, that line of corpses, lunging for me in the dark… My father, gaping in that monstrous leather jaw… My mother, falling in the parlor, hand outstretched… My brother George, bloody hands gripping the barbed wire tight… My brother Michael, eyes staring up, sinking down, reaching for me… I see them… Even now…<u>even now</u>…

He closes his eyes.

Keeps them closed.

PETER: Do you see them?

This is harrowing for him.

PETER: I want to hear the mermaids singing to the moon... I want to be young, with my brothers... I want to be sane again and whole... I want... I want...to jump on the wind's back and away we go...

He opens his eyes.

PETER: But here we are. Awake again. Into truth.

ALICE: I can't afford your truth. I need mine.

PETER: Even if it's not real?

A beat as she gazes at him.

She finally stands.

It's a little difficult getting up. She feels her age.

She looks at him: dead on.

ALICE: Shall I tell you about reality, young man? ... When my son Alan was killed in the war, and my son Rex was killed in the war, I thought I could not know more suffering. My husband did not recover from the shock, honestly. He did not understand where his boys had gone. He got very old and I with him. He died six years ago, my gallant Mr. Hargreaves. After 46 years of marriage.

Beat.

ALICE: It was then I learned the estate was in less than ideal shape. He had not overseen our finances with the acumen I had expected. That fell to me. I found I could no longer afford to keep the staff intact; those seven pretty maids are no more, Mr. Davies. Cuffnells is a large house and expensive to maintain, so I've closed most of the rooms and spend my days in the library, at the top of the house, where there's little heat and it's very drafty... As I told you,

I sold Mr. Dodgson's manuscript for the money. Because I had to... But what will I sell next year?

Beat.

ALICE: My son Caryl and his wife look in on me every now and then, but I bore them so they find excuses to come less and less. My father and mother are long since dead, so too my sisters, so too my friends. No one comes to visit me. I see no one. <u>I am alone</u>... Do you know what it is to be 80 years old and sick and alone? Do you know that truth, Mr. Davies?

Beat.

ALICE: And if I sit there in that room at the top of the house and I think about my life and if I shut my eyes from time to time and imagine being warm in the summer and I hear the bees buzzing and for a moment I truly am Alice in Wonderland, do you have the heart to tell me I'm not?

She advances on him:

ALICE: I can be the lonely old woman in the drafty room or I can be Alice in Wonderland... <u>I choose Alice</u>.

Beat.

ALICE: So, now the choice is yours.

PETER: I don't know what you mean.

ALICE: It's your life. Not Mr. Barrie's. Not your brother's. Yours... So choose.

PETER: What would you have me do?

ALICE: I would have you live.

PETER: Believe in fairies?

ALICE: Why not?

PETER: Dance to the pipes in the deep, dark woods?

ALICE: Take my hand. We'll go together.

She holds out her hand.

He looks at her.

At her outstretched hand.

ALICE: I'm a dying old lady, not much loved by anyone… But I know the way to Wonderland.

He longs to.

More than anything.

But he can't.

His heart breaks.

PETER: I have grown up.

<u>*The backroom of the bookshop reforms around them.*</u>

Fantasy and memory are banished.

Except…

PETER PAN and ALICE IN WONDERLAND remain with them, on the fringes, like ghosts, like shadows, watching.

ALICE hears voices off.

She glances through the door into the bookshop.

ALICE: I believe they're ready for us, Mr. Davies.

PETER: Oh…of course.

ALICE: I'll see you inside then.

She steps to exit into the bookshop.

But then she stops in the doorway, looks back at PETER.

Almost as if she has one more thing to say.

ALICE IN WONDERLAND: *(To PETER PAN.)* Two years later, Alice Liddell Hargreaves died peacefully in her sleep.

ALICE exits into the bookshop. PETER starts to follow her. He turns.

PETER PAN: *(To ALICE IN WONDERLAND.)* Some years after that, Peter Llewelyn Davies walked down into the Sloane Square tube station and threw himself in front of a train.

PETER stands for a moment, looking at PETER PAN.

PETER PAN leans forward, yearning.

PETER turns and leaves, slamming the door behind him.

PETER PAN turns to ALICE IN WONDERLAND.

Blackout.

The End.

Printed in the USA
CPSIA information can be obtained
at www.ICGtesting.com
LVHW021514231024
794622LV00002B/445

9 781350 265912